MASTERS OF PHOTOGRAPHY

LEWIS CARROLL

Text by Graham Ovenden

Macdonald

A MACDONALD BOOK

© Macdonald & Co (Publishers) Ltd 1984

First published in Great Britain in 1984
by Macdonald & Co (Publishers) Ltd
London & Sydney

A member of BPCC plc

British Library Cataloguing in Publication Data
Ovenden, Graham
 Lewis Carroll.—(Masters of
 photography)
 1. Carroll, Lewis
 I. Title II. Series
 770'.92'4 TR140.C28/

ISBN 0-356-10508-3

All photos courtesy Graham Ovenden, with the
exception of *The Rossetti Family*, National
Portrait Gallery, London.

Filmset by
Text Filmsetters Ltd

Printed and bound in England by
The Alden Press
Oxford

Macdonald & Co (Publishers) Ltd
Maxwell House
74 Worship Street
London EC2A 2EN

One of the most interesting phenomena to occur during the early days of photography was the emergence of the dedicated amateur. Unlike the popularity of instantaneous picture making today, amateur photography of a century ago was involved to a much greater degree with application and aesthetics. Indeed, if we evaluate the remarkable achievements of the select group of photographers working during the mid-1800s, the status of 'amateur' by today's low standards hardly seems applicable. Among them were numerous Sunday masters whose legacies far outstrip those of the professional photographer; of these, three names stand out and demand particular respect. By sheer force of will Julia Margaret Cameron created the great portraits of the High Victorians; Clementina Lady Hawarden's personal vision has left us a unique, poetical document of her inner domestic circle. The third, and the subject of this essay, is Charles Lutwidge Dodgson (hereafter referred to by his *nom de plume*, Lewis Carroll), an 'amateur' photographer who proved himself to be the most obsessive enthusiast of all.

Lewis Carroll was born on 27 January 1832 at Daresbury parsonage, a rather isolated environment a mile and a half from the small village of that name. His early childhood seems to have been happy and all surviving evidence points to a child respected by his brothers and sisters (there were 11 in all) and loved by two considerate parents. When Carroll was 11 the family moved to Croft in Yorkshire, a crown living presented to Carroll's father by Sir Robert Peel.

Even at this early age Carroll possessed the ability to amuse his siblings, a talent he was to use later in his career as both author and photographer. A train and many stations, for example, were set up in the large garden at Croft, and 'Railway Rules' written in Carroll's own hand still survive, indicating the enthusiasm with which such games were played. Another favourite trick of the young Carroll was to dress up in a shirt and wig and pose as a philosopher, to the amusement of an admiring audience. One inclination of particular importance at this tender age was Carroll's interest in the theatre. Although the live stage was still very much frowned upon by the older generation (it is amazing to think that in a period of such theatrical richness none of Carroll's sisters ever attended a commercial performance), Carroll was able to construct a marionette theatre and proved to be a great manipulator of puppets and, of course, writer of dialogue.

Perhaps the most interesting survivals of this early period are the magazines Carroll wrote for home circulation. The most instructive, as a foretaste of things to come, are 'Misch-Masch' and 'The Rectory Umbrella'. Here one already can detect the seeds of an original and inventive mind. As well Carroll was no mean craftsman in his early years and objects that survive, from hand-drawn card-games to miniature woodworking tools, give an indication of abilities that were to prove valuable when his hobby of photography began in 1856.

Carroll's first experience of the outside world came when he was sent as a pupil to Richmond in 1844, where he remained for two years. Here he gained respect for his seriousness, a model pupil indeed. Sadly, a rude awakening awaited: his subsequent attendance at Rugby proved to be a time of mental and physical hardship, and one can only respect the inner resources that enabled Carroll to endure the rigours of public school. Even so, his abilities in mathematics and divinity were praised by A. C. Tait, the kindly though rather bland headmaster of Rugby.

Oxford was the next step in Carroll's education and, following his father's footsteps, he matriculated at Christ Church. Rather like the Victorian painter George Frederick Watts, who came on a short visit and stayed for 30 years, Carroll went up in 1851 and remained at the University for the rest of his life. After taking his MA with a first in mathematics, a second in Classical Moderations and a third in history and philosophy, he was elected a Student of Christ Church, becoming Sub-librarian, Lecturer and, finally, Curator of the Common Room. Christ Church was to be Carroll's whole adult experience for 47 years with little to break the slow rhythms and systems of its traditions.

Today, more than 80 years after his death, the quads and gardens of the University still hold much of the romantic insularity which must have been

even more apparent during Carroll's stay. While many minds of genius have passed through these halls, there seem to be few who were more firmly entrenched in its mythology, so absolutely at one with its mysterious mechanisms than the creator of the Alice books.

To appreciate this sensitive artist, a manipulator of two-dimensional magic who, for personal pleasure (not to say personal anguish) devoted some 24 years to the practical problems of the wet collodion process, the fixing of the fleeting shaft of light, let us chart his progress in the 'black art' in detail.

The story begins with a summer visit in 1855 to Croft Rectory by Skeffington Lutwidge, a favourite uncle. Lutwidge, like many Victorian gentleman amateurs, had an instructive and inventive turn of mind and often brought scientific novelties to delight the young Carroll. On this particular occasion the comparatively new art of photography proved to be his latest enthusiasm. A diary entry for 8 September reads, 'Uncle S. took photographs of the church, bridge etc., but not very successful ones.' Obviously the manipulation of the calotype process was proving wayward for this inexperienced practitioner. Even so, such poor results fired the young Carroll's imagination and within the week a pamphlet, 'Photography Extraordinary', had appeared in the household.

This was also the year of Carroll's election to the Senior Common Room at Christ Church. His income grew accordingly and the expense of his photographic equipment could now be borne. On 22 January 1856 he wrote to his uncle asking him to purchase the necessary photographic materials. Skeffington must have proved reluctant in this commission as we next learn of Carroll's expedition with fellow enthusiast Reginald Southey to London on 18 March to order a camera and sundries. The sum of fifteen pounds is mentioned, indicating how photography was far beyond the purse of any but the middle class and above.

As is often the case with many beginners, now as then, all was not plain sailing. The attempts of 25 April with a camera proved fruitless but finally, after much labour, on 1 May a successful image of Southey was made, similarly on 10 May, after many attempts, of the young Harry Liddell. On 13 May a diary entry reads, 'Southey spent a long time making up developing fluid etc. for me, so that I am now ready to begin the art'; and on the 15th, 'Took several likenesses in the day, but all more or less failures.' The first indication of success is recorded on 3 June: 'Spent the morning at the Deanery, photographing the children.' (Does this include the small oval of Alice? She was then aged four; it is a possibility.) An important early photograph is that of Alice Murdoch, taken on 19 June and pasted into Carroll's first album. The accompanying dedicatory verse shows how close to the new art lay Carroll's emotions.

If we compare Carroll's first success with Mrs Cameron's 'Annie, my first success' – a rightly celebrated work – we can see Carroll's comparatively modest beginnings. A charming enough likeness, Carroll's portrait has none of the inner intensity we find in later pictures. While Julia Cameron's photograph is a great portrait on any terms, Carroll's work does not yet express his true genius.

Carroll's diaries are of singular documentary value. Through the combination of entries and photographs, we can feel the actual process of creation. Few photographers have left so precise a documentation of their activities as the author of the Alice books. Apart from the missing diaries, which cover the period from May 1858 to May 1862, we have a complete account of Carroll's pursuit of visual immortality. The entries, made almost daily, give a vivid picture of an ardent obsession. They also give us a great deal of information about his aspirations, although they seldom touch on his emotional experiences.

After Carroll visited the Exhibition of British Artists on 27 April 1857, he wrote in his diary that, 'I never saw so many good pictures there. I took hasty sketches on the margin of the catalogue of several of the pictures, chiefly for the arrangement of hands, to help in grouping for photographs.' Here we see not only Carroll's almost obsessive need to translate visual experience into potential photographic imagery, but a self-conscious attempt to master the formalities of composition – what eventually was to become a unique strength in his work.

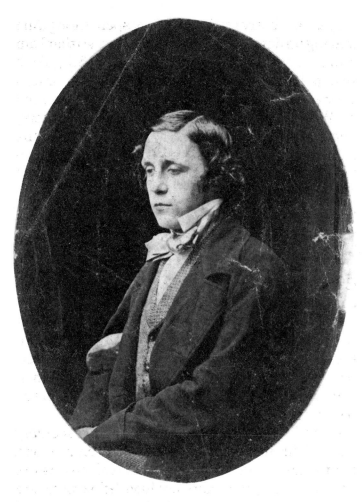

Lewis Carroll (Charles Lutwidge Dodgson), c. 1856

Of the latter he is a nineteenth-century master and ranks with Hill and Adamson and Fenton. Time and again when observing Carroll's best work one is struck by the natural rightness of his compositions, which elegantly contain the inner vitality of his subjects. This emphasis on containment reflects the personality of the Oxford Don. Emotional displays were not in his nature; he guarded his feelings and expressed them only in the presence of his beloved children. Yes, there was an element of the lover in Carroll's relationships with his little girl friends, but it was sublimated to a spiritual plane. There are the seeds of anguish, even tragedy in his encounters. The best of Carroll's photographs are secretive and only on close acquaintance can the observer perceive the evidence of his inner struggle.

Although Carroll's reputation as an original artist lies with his intimate portraits of children, one must not neglect the fact that his repertoire included famous men and women, occasional landscapes and numerous copies of artefacts, works of art and the like. The last are of little interest in their own right, save for the insight they provide concerning Carroll's taste in the visual arts, which was sadly conventional (he did, however, possess one painting of quality, *The Lady of the Lilacs* by Arthur Hughes. One can see it hanging over the mantlepiece in the photograph of his room at Christ Church). Also revealing are a group of photographic copies Carroll made of his collection of drawings, watercolours and print by W.S. Coleman. They are nearly all overtly sexual renderings of nude young girls, of moderate technical accomplishment but highly charged. An insight, perhaps, into a darker side of Carroll's attraction to adolescence.

Turning to less delicate matters, one of the more interesting of Carroll's encounters was with the poet Alfred Lord Tennyson. A diary entry of 18 August 1857 shows well the tremulous determination with which he would pursue his quarry: 'A party came down from the Castle to be photographed, consisting of Mrs Weld and her little girl Agnes Grace, the last being the principal object. Her face is very striking and attractive and will certainly make a beautiful photograph. I think of sending a print of her through Mrs Weld for Tennyson's acceptance.' Having heard of Tennyson's approval of his rendering of Grace (he entitled one of the two portraits 'Little Red Riding Hood'), Carroll travelled to Ambleside hoping to meet the inmates of Tent Lodge. On 18 September he wrote, 'I therefore walked... intending at least to see Tent Lodge (Coniston) if not to call. When I reached it at last I made up my mind to take the liberty of calling. Only Mrs Tennyson was at home.... I also saw the two children, Lionel and Hallam....' On 22 September Carroll met the object of his pursuit: 'Brought my books of photographs to be looked at [This was to become a regular ploy when seeking new models]. Mr and Mrs Tennyson admired some of them so much that I have strong hopes of ultimately getting a sitting from the poet....' After a frustrating technical hitch on the 24th the

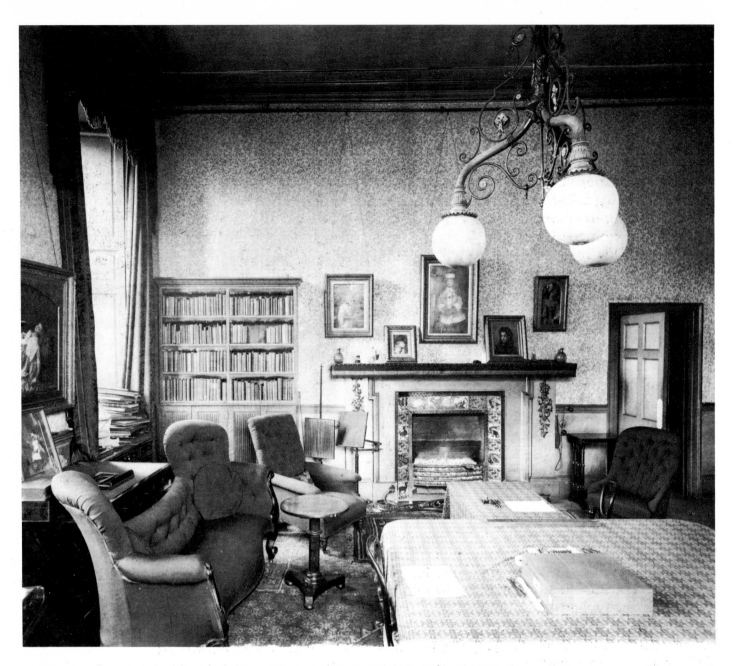

Carroll's study at Christ Church, Oxford, 1898

entry of the 28th reads, 'Went over to the Marshalls about 11 and spent the day till 4 in photography. I got a beautiful portrait of Hallam, sitting, and a group in the drawing-room of Mr Tennyson and Hallam, Mr and Mrs Marshall and Julia.'

This particular encounter must have been considered a great success. Alas, not all such expeditions and requests for sittings were so fruitful. Unwilling sitters, technical problems and incle-

ment weather foiled carefully laid plans. The terse comment, 'The pictures failed', occurs with great regularity in Carroll's diaries. For these reasons one cannot help but be impressed by his tenacity and, knowing well his shy disposition, one can only assume some inner urge to capture on collodion the great and distinguished of his time. Was this merely a form of pandering to a superior class, or a genuine wish to make concrete the face of history? Certainly Carroll's portraits of famous people,

although of interest, have little of Julia Cameron's psychological insight. No, on balance one of Carroll's renditions of the mysterious state of childhood is definitely worth the lot.

Carroll's next major effort was an excursion into literary parody: 'Hiawatha's Photographing' was finished on 13 November 1857 and proved by far the most successful and entertaining work yet penned on the subject. The following year, 1858, Carroll's most significant photographic endeavour was the exhibition of four prints at the Fifth Annual Show of the Photographic Society of London, the only recognizable image being Grace Weld as Little Red Riding Hood.

The public exhibition of photographs was a novelty for Carroll and its glamour proved of short duration. Indeed he became more private and insular as the years passed, and yet time and again his enthusiasm for the medium forced him out of isolation, sometimes ending in humiliation — as in the case of an attempted sitting by the Prince of Wales — or in numerous frustrations, such as his relationship with Dean Liddell's formidable wife. No doubt she, and others, looked with more than a little suspicion on the antics of the photographic Don.

Alice Liddell and her sisters Edith and Lorina were crucial to Carroll's creative drive: the telling and then the production of that most marvellous story, *Alice's Adventures Underground*; its final revision and enlargement into *Alice's Adventures in Wonderland*; followed by *Alice Through the Looking Glass*. One is grateful that in Carroll's photographic oeuvre there are many fine portraits of the sisters. Two in particular, Alice posing as a beggar-child, and another captured in profile in dream and melancholy, are masterpieces.

What, we may wonder, was the relationship between Carroll the photographer and Carroll the spinner of fantasy? Were they the same being? In a way, yes: his finest images do have a direct affinity with the inner fantasies of his mind; his subjects are lost in that world of curious yet intense childhood realities, unsullied by logical experience. Their drama is of the mind, action is sublimated; not even a breath of wind intrudes to break the awesome silence. Carroll's finest images bor-

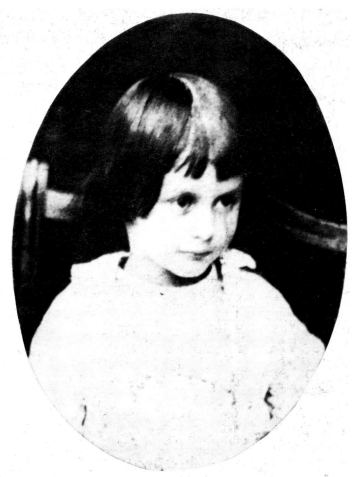

Alice Pleasance Liddell, c. 1859

der on melancholy, even despair. The emulsion catches the moment never to be repeated; the subjects grow up, cease to be what they were, and yet, by this strange alchemy, remain fixed forever in their precious state of grace. The anguish of nostalgia has taken on the guise of art.

Fortunately for posterity there are enough surviving pictures to enable us to call Carroll a master. But, to be impartial, much of his work is little more than record-making, and his later photographs in particular, although charming, lost a great deal of the intensity one sees in his work of the 1860s.

Carroll's childhood interest in the theatre flourished in adulthood. As an ardent theatre-goer, his sense of the other reality must have been developed to a greater degree than most. Yet it is a pity that amateur theatricals became such a part of his photographing habit. Certainly they must have been enjoyable for the young participants; but the

tableau vivant, by its very nature, created a false existence. Carroll's set pieces, although skillfully organized, remain totally earthbound. As a record they are charming but fail to live up to his highest standards.

One offshoot of Carroll's theatrical interest was his friendship with the Terry family. Ellen, the eldest daughter, became the finest Shakespearian actress of her age. She combined genius and beauty and there is little doubt that during their twenty-odd years of association, Carroll fell not a little in love. In her autobiography Ellen writes with touching fondness of their relationship and fortunately, as with Alice, a group of portraits survive that capture this. Nineteen of Carroll's original negatives of the Terry family still exist and they are among the most telling and delightful of his output. A large print of the assembled family is a particularly fine example and shows a great sense of organization without a loss of vitality. The double portrait of Polly and Flo, Ellen's two younger sisters, is also a masterpiece and stands head and shoulders above competitors in this field.

Here again a fruitful friendship evolved through a combination of childhood interests and photography. We read of Carroll's visit to the Terry's on 20 August 1864 when photographs were exchanged and an arrangement made to photograph the family (an event which did not take place until the following year). An entry of 7 April 1865 reads, 'Went to Kentish Town, to call on the Terrys. Found the party including Mrs Watts at home [Ellen had married the painter Watts when only fifteen years of age]. Their new house has a garden behind, which I hope to use for photography in the summer.' Thirteenth of July: 'Drove over to the Terrys with the camera etc. All are at home except the eldest two boys. It rained a good deal of the day, and I only took three pictures – Polly, Mrs Watts half-length, and Mrs Watts with Flo.' Fourteenth of July: 'Spent the day at the Terrys and took Miss K. Terry, Mr and Mrs T., Mrs Watts, a large one of Polly, Polly and Flo, Flo, Charlie, etc.' Fifteenth of July: 'Did not get to the Terrys till 12½, where I photographed till about 4½.'

Carroll was very much interested in the technical side of photography. A youthful love of gadgets no doubt influenced his desire to possess a number of cameras (a syndrome not uncommon in our own time). His negative sizes ranged from 8 × 10 to 3¼ × 4¼ inches. The negative process Carroll and his contemporaries used was the wet collodion, or wet-plate, process. This involved the sensitization of collodion with silver nitrate which, once applied to a glass plate, had to be exposed while still wet (drying led to substantial desensitizing). After exposing, developing and fixing, and washing and drying, it was deemed advisable to protect the delicate surface of the emulsion by varnishing it. If one were fastidious, as Carroll was, the result could prove to be a negative of substantial latitude, especially good in halftones. If haphazard in application – as was Julia Cameron – a number of disasters could ensue – uneven development, finger marks and dust spots, to name but a few.

Following general practice, Carroll did not enlarge his negatives; all of his prints were contact prints made in the sun using sensitized albumen paper (which was commercially available) as the vehicle. The final results could then be gold-toned or straight-fixed, depending on whether purple-blacks or sepia tones were required. Carroll sent a number of negatives out to be commercially printed, but in general – and particularly for his personal albums – he was meticulous in carrying out the process from start to finish.

Carroll's technical ability ran parallel with that of his artistic development. Even so, self-assurance did not keep him from seeking expert advice when the situation demanded it. When his rooms at Christ Church proved inadequate for his photographic pursuits, he sought the expertise of Gustave Rejlander, one of the major names of High Victorian art photography. His diary for 22 April 1863 reads, 'Called at Badcock's [a draper's shop] to see if his yard will do for photographing: I think myself it will, but have written to Mr Rejlander to come over and give advice about it.'

Another indication of Carroll's seriousness towards his art was the eventual building of a studio above his new rooms at Christ Church. From his entry of 21 June 1868 we read, 'My present task is to arrange for the necessary alterations in Lord Bute's rooms, before moving into them, as I have

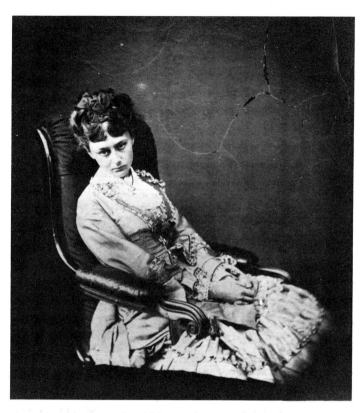

Alice Pleasance Liddell, 1865

must have been mentally ill since he wished to photograph young girls in the nude. Fortunately, those who have access to nineteenth-century photographic collections and the Edwardian postcard phenomenon know that the photography of nude children (of both sexes, but in particular of the girl child) was the norm rather than otherwise.

The first reference in Carroll's diaries to nude photography occurs on 21 May 1867: 'Mrs L brought Beatrice, and I took a photograph of the two; and several of Beatrice alone, "sans habilement" [sic]'. There were numerous such entries over the years and it is unfortunate that as yet this large part of Carroll's oeuvre has yet to surface.

The following letter of 14 March 1877 reveals Carroll's fastidious regard to etiquette but also an equivocal sense of responsibility where the authorship of nude imagery was concerned:

settled to do. There seems a bare possibility of my sible from the rooms, which would be indeed a luxury, and as I am paying £6 a year rent for my present one [Badcock's yard], I should soon save a good deal of the outlay.' His first use of these new premises was not until 17 March 1872: 'Yesterday I took my first photo in the new studio – Julia Arnold.' The luxury of a well-designed studio is apparent in an entry for 30 January 1873: 'Took a photograph (remarkably good for the winter) of Helen Feilden.' Carroll could now attend to his hobby during all seasons and in all but the poorest weather conditions.

Over the years Carroll's photographs of nude young girls have caused considerable discussion. The fact that the four surviving hand-coloured examples now in the Rosenbach Foundation were long unavailable for inspection has added to the atmosphere of mystery and conjecture. It would seem that lack of evidence has led to rumours and comments of an unpleasant nature concerning Carroll's motives. I remember Malcolm Muggeridge stating in an interview that he thought Carroll

Dear Mrs Hatch;
You know that photo I did of Birdie, seated in a crouching attitude, side view, with one hand to her chin, in the days before she had learned to consider dress as de rigueur? It was a gem the equal of which I have not much hope of doing again: and should very much like, if possible, to get Miss Bond, of Southsea (the best photographic colourist living, I think) to colour a copy. But I am shy of asking her the question, people have such different views, and it might be a shock to her feelings if I did so. Would you kindly do it for me? However particular she may be, I don't think she can reasonably take offence at being asked the question by a lady, and that lady the mother of the child in question. What I want you to do is to send her a description of the photograph (you may as well tell her that I took it), and simply ask her if she would be willing to colour a print of it. Then if she says 'no', there is no harm done; but if I hear from you that she says 'yes', I can then negotiate myself...
Believe me, Miss Bond,
Sincerely yours, Park Lodge,
C L Dodgson Southsea

Carroll's last diary entry relating to photography was made on 15 July 1880: 'Spent morning in printing. Gertrude and Gerida Drage came at 3, and I spent two hours photographing them: then toning, fixing etc. till 7.' This brief entry leaves us with a question. One expects some explanation or indication as to why photography ceased to be the major thread of Carroll's life. But, as with much of his character, the mystery remains. Some commentators suggest that the introduction of dry-plate photography provided an excuse for Carroll to comply with an already firm decision to abandon his practice, because the wet-plate process could have continued *ad infinitum*. Yet the amateur is not as shackled as the professional where process is concerned. Gernsheim emphasizes Carroll's need to complete a multitude of literary projects, and this seems more plausible. The perennial rumour of scandal may play a part and recent research indicates this as a possibility. But one must be aware that Carroll was ultrasensitive in matters of etiquette. Any suggestion of impropriety would have closed the door; the length of an acquaintance would not matter one jot. One must therefore be wary of reading sinister aspects into the case and if there is an answer, it probably lies in a combination of reasons. Carroll was a master of nonsense and illogic and this is reflected as much in his life as in his literary work. Perhaps, in fact, the mystery is more rewarding than the actuality.

And so Lewis Carroll, like his White Knight, continued to suffer the slings and arrows of fortune.

Of his surviving prints and albums at least a third are works of art. The albums in particular were cherished possessions to be displayed for admiration or as a means of obtaining sitters. But they were also much more. One cannot but suspect that the most prized portraits, such as Alice posing as a beggar-child, Gertrude Dykes and a host of other children, were not just prints on a page but the never, ever changing image of the daughter this bachelor Don never possessed. Were these then his children of the mind? One would like to think that the images that sped past this sad genius were the ghosts he so admirably fixed on to paper.

Carroll's photographic achievement lay in his ability to make concrete that which is transitory. In general his images are restrained and natural, at first sight unassuming but on closer acquaintance rich in repose. His children see further than the page of the carefully positioned book and their serious observation reminds us poignantly of what we once were: the receptacles of unprejudiced knowledge, innocents abroad in a wonderland of experience.

More than one art historian has rightly pointed out that one of the hallmarks of true art is a sense of stillness, the ability to move one step away from the observed. To these qualities one might add the edge of anguish and the results prove vital indeed. Carroll possessed these and therefore demands our respect. Even more, perhaps, he enriches our understanding and makes valid comment on our desire to return to that first, precious state of grace.

FRAMING AND MOUNTING

There are a number of ways to display photographs, depending on your personal taste, the picture itself, your initiative and the amount you wish to spend. The simplest method is to use ready-to-assemble framing kits, which will only take about 10 minutes of your time; but if you want a truly professional look, you might wish to mount or mat your photographs and then have them framed – or do it yourself.

Mounting

Like any kind of print or drawing, a photograph must be secured to a stiff surface before it is framed to keep the picture flat and to keep it from slipping about inside the frame. There are a wide variety of mounting boards available, in many colours and thicknesses, or weights, so it is best to go to an art shop, tell the assistant what you need and look through their stock. Remember, if the photograph is large you will not want the board to be so heavy that when the picture is framed it falls off the wall!

There are three mounting techniques: dry, adhesive and wet. Dry mounting should be left to a professional (most photographic processing firms offer such services) because it requires a special press, but the other two methods can be done easily at home.

Adhesive mounting

You will need a sheet of glass slightly larger than your mount to use as a weight; a soft cloth or rubber roller (4-6 in/10-5 cm) and a wide brush. When choosing the adhesive avoid rubber solutions because they lose their adhesiveness when they dry; spray adhesives (which can be bought in any art shop) are quick and less messy – test the spray on a piece of paper before you begin to gauge its density. Sheets of adhesive are also available but require a perfect eye and steady hand. If you feel confident, they are an easy way to mount a picture. Tape should not be used except as a temporary measure.

First calculate where the picture is to lie on the board and lightly tick the four corners with a pencil or prick them with a pin. Read the manufacturer's instructions on the adhesive and then apply it to the back of your print. Carefully position the print on the front of the mounting board and smooth out any wrinkles with the roller or cloth, working from the centre outwards.

Because the mount will tend to warp as the adhesive dries, the picture must be countermounted. Cut a piece of heavy brown craft paper the same size as the mount. Lightly dampen one side of the paper with clean water, apply adhesive to the other side and then secure it to the back of the mounting board. As the paper dries, it will counteract the drying action of the photograph. Place the picture and mount under the sheet of glass until completely dry.

Wet mounting

Wet mounting is used for creased, torn or very old photographs. Immerse the photograph in clean water and place it face down on a sheet of glass. Using a brush or roller, carefully smooth the surface and apply a thin coat of adhesive to the back of the picture and to the mounting board. Put the picture on the board and gently press out any bubbles. Countermount the board (see above). Check the photograph for any wrinkles or bubbles and smooth out. Let the adhesive dry until it is just moist and place the mounted photograph under the sheet of glass and let dry completely.

Block mounting

This is especially effective for large photographs and means that no frame is needed. Self-adhesive commercial blocks are available in standard sizes but tend to be expensive. To make your own you will need a piece of mounting board about 3/8 in (9 mm) smaller than the print on all sides; cellulose adhesive, a brush, lots of newspaper, a soft cloth or

rubber roller, a large piece of card, a sharp craft knife, a cutting mat and piece of fine glasspaper.

Mix enough cellulose adhesive to cover the print and the board (the board will absorb the first few coats, so make a lot). Soak the photograph in clean water for about 20 minutes. Place several layers of newspaper on your work surface and place the mounting board on top. Apply the adhesive to the back of the board in two applications. Remove your print from the water, let any water drip off and place it picture-side down on the work surface and cover the back with adhesive. Then position it carefully on the board, picture-side up. Using the soft cloth or roller, carefully push out any bubbles or wrinkles from the centre outwards. When dry, put the mounted print picture-side down on a piece of clean card (do not use newspaper or paper, which may damage the print). Put some heavy books evenly on top as a weight and let dry thoroughly (this can take up to two days.) When dry, put the board picture-side down on a cutting mat and, using a sharp knife, trim the excess edges of the print to the edges of the mounting board. Smooth the edges of the board (not the print) with glasspaper. Paint the edges of the board or leave neutral.

Matting

A mat can change any photograph into something quite stunning. It will require a certain amount of experimenting to determine what size border around your picture looks best: some photographs are heightened by having a very wide border, others need almost none at all. In all cases, however, it looks best to have the bottom border slightly wider than the other three. As well, there is a vast range of colours of board to choose from, so think these things through before you buy your supplies. Remember that the mat should never overwhelm the picture, but should simply enhance it.

You will need a very sharp craft knife, metal straightedge and steel tape, large or set square. cutting mat and sharp pencil.

First measure the board to make sure that it is square (the right angles at the corners should be exactly 90 degrees) and trim if necessary. The aperture, or opening, for your picture should overlap the print by about ⅛ in (3 mm) all round. You can mark this on the board either in pencil or with pin-pricks at the corners. If marking with pencil, do so on the back of the board and cut from the back as well so that the marks will not show.

Before you begin cutting, it is a good idea to practise using the knife and straightedge, which can be tricky for the uninitiated, especially on the corners. Position the blade of the knife at either a 90-degree (for a vertical edge) or 45-degree (for a bevelled edge) angle to the straightedge. Draw the blade firmly and slowly from corner to corner. Avoid stopping, as this will produce a ragged edge, and be careful not to gather speed and overshoot the corners. When all four sides have been cut, lift the centre out. Use glasspaper to neaten the edges.

The mat can now be secured to the mount with adhesive. To make a permanent bond, coat both the mount and the mat with adhesive, let dry and then press together. For a less permanent bond, apply adhesive to only one surface. Your picture is now ready for framing.

Frameless Frames

Photographs can be displayed most effectively without frames to detract from them. There are many types of frameless frames available in standard sizes, from 8 × 10 in (18 × 24 cm) to 24 × 32 in (50 × 70 cm). Most are easily obtained from art shops – your only decision is the size you need and the amount you wish to spend. If you prefer, you can easily make your own. You will need mounting board, a mat, glass or acrylic, and clips or brackets. There are, again, a wide variety of clips and brackets available. The least obtrusive are known as Swiss clips. Whichever you choose, make sure they will fit the width of the mount, print, mat and glass.

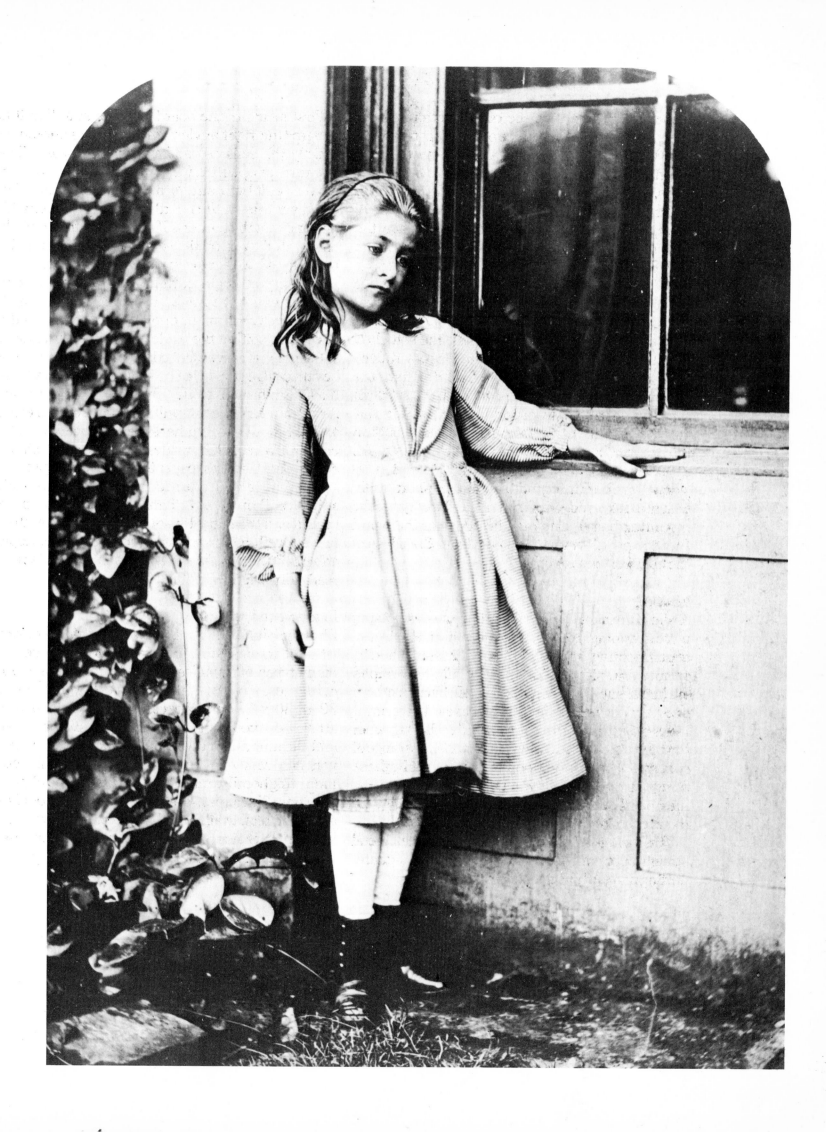

Gertrude Dykes, 1862

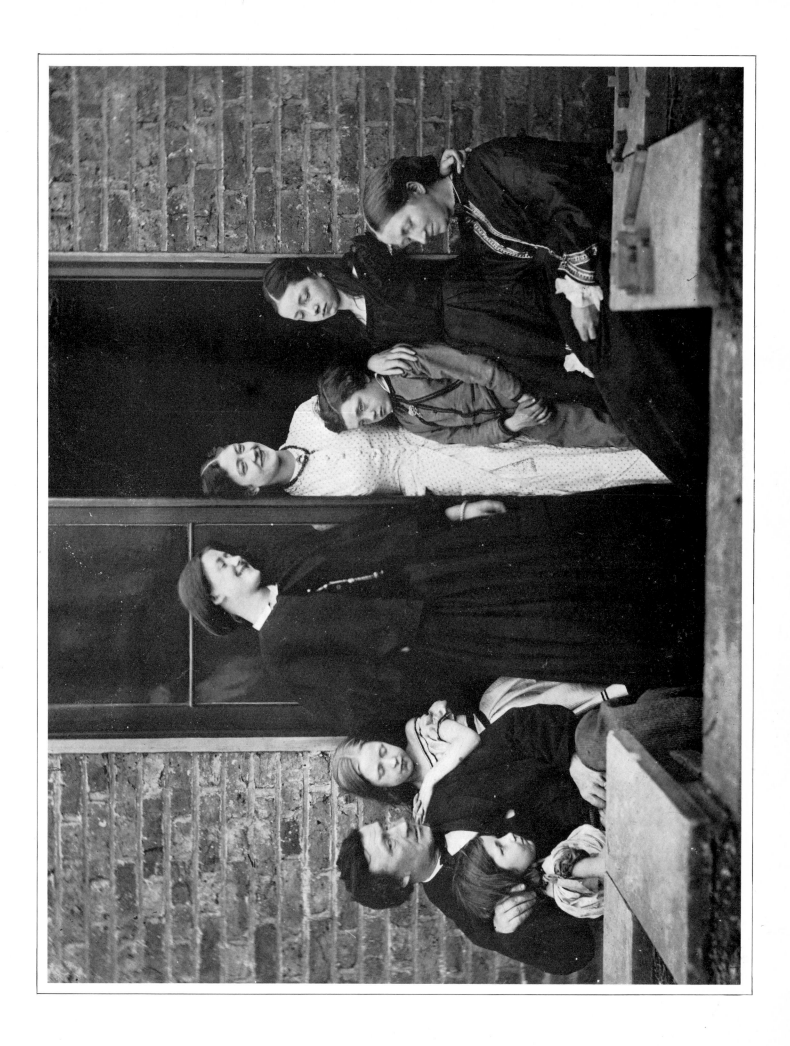

The Terry Family, 1865

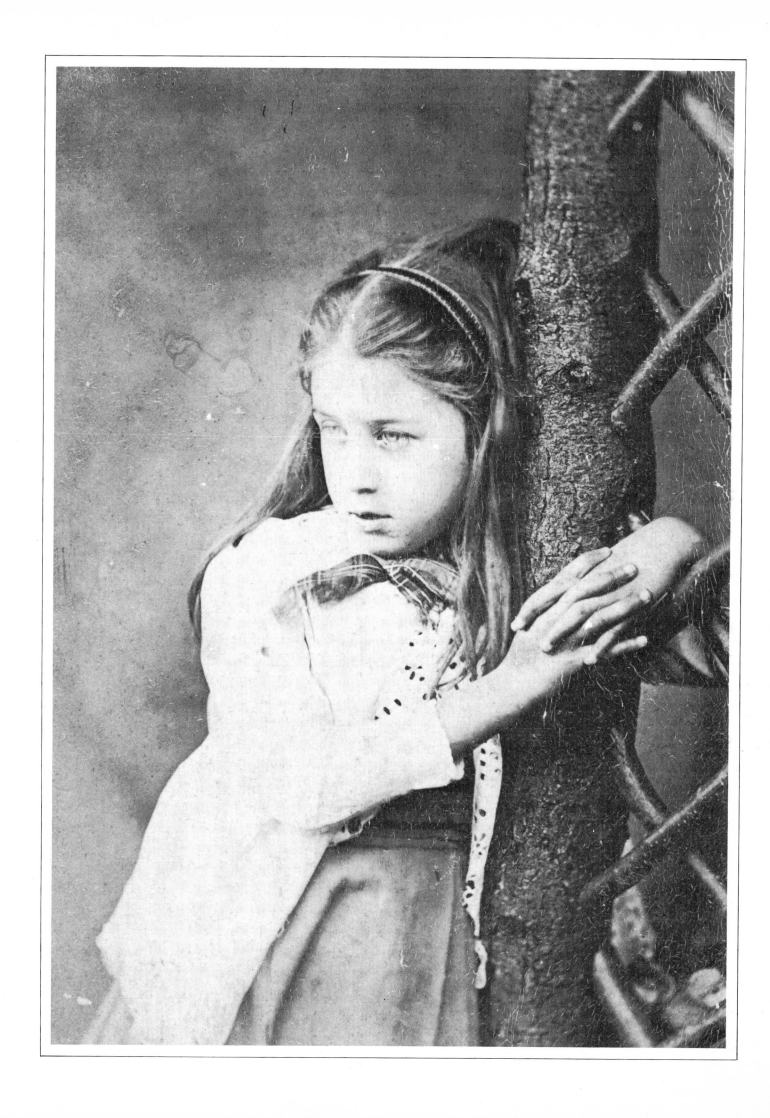

Mary Florence Hulme, carte de visite, c. 1865

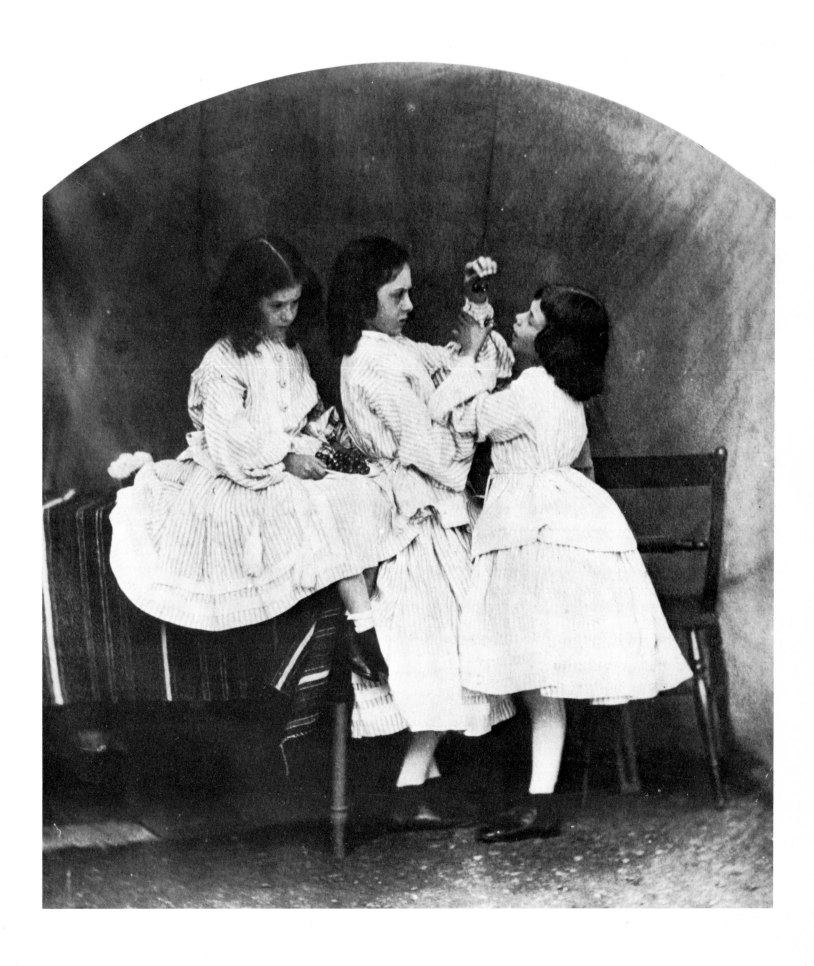

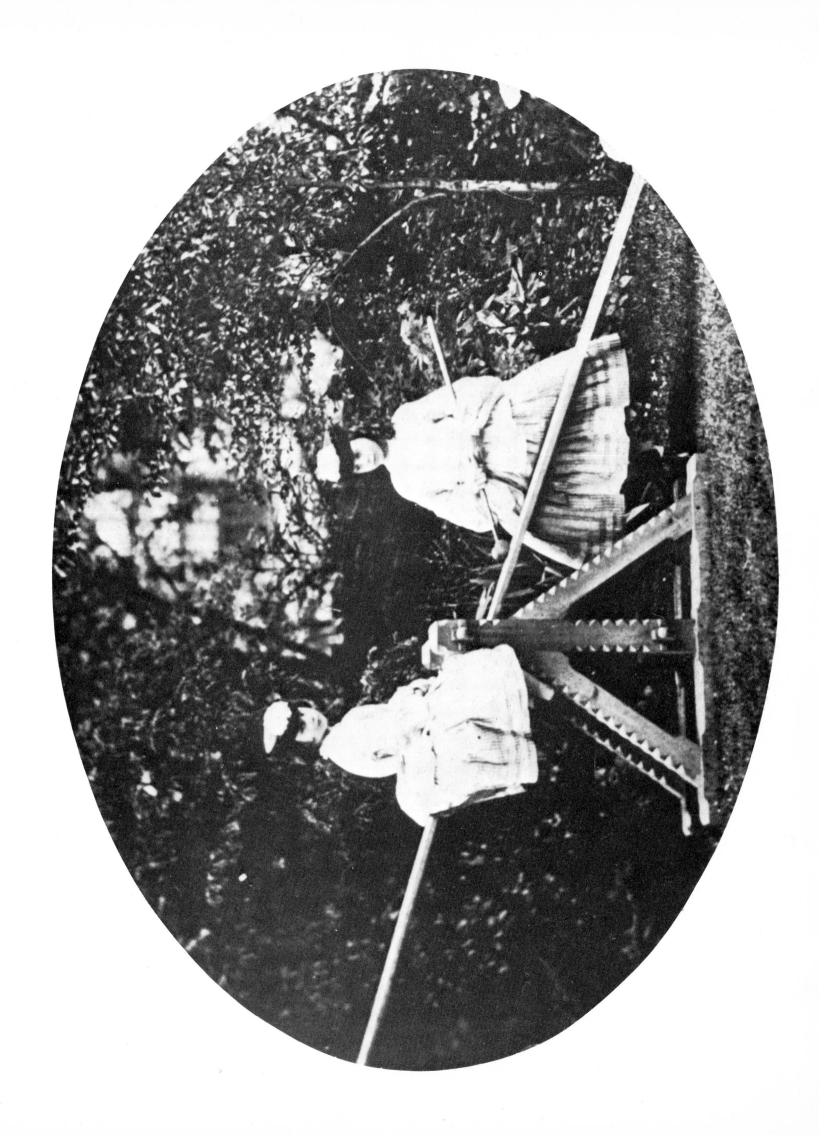

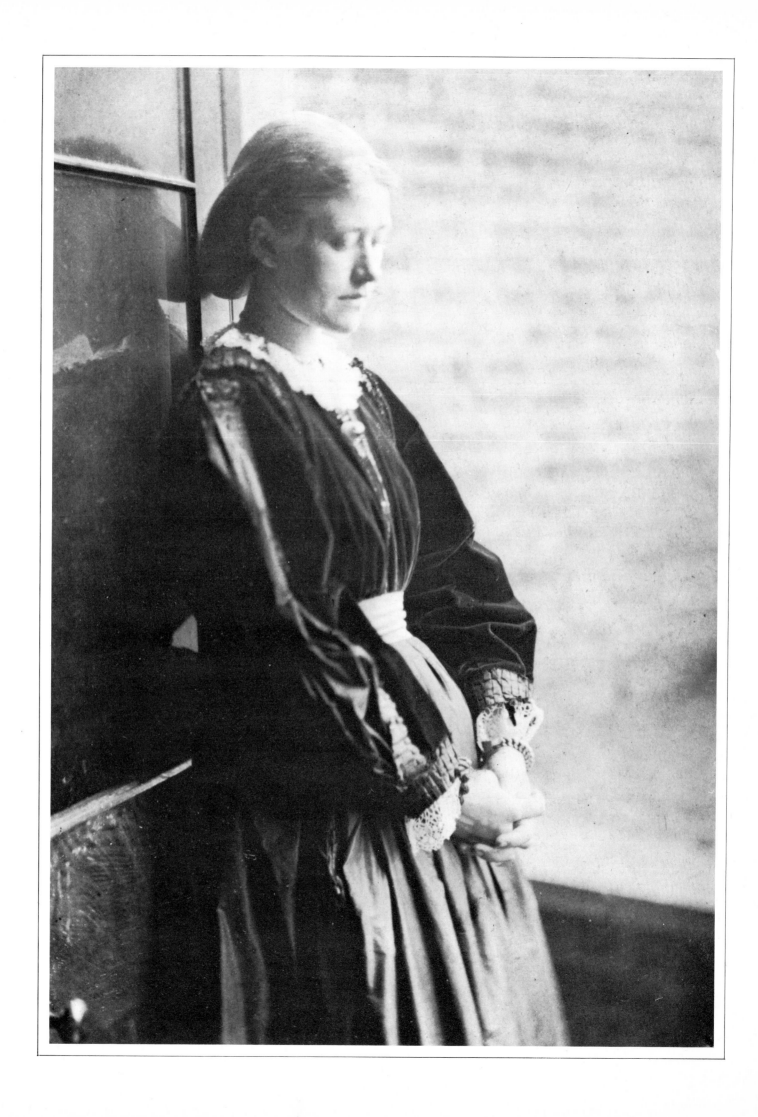

Ellen Terry, 1865

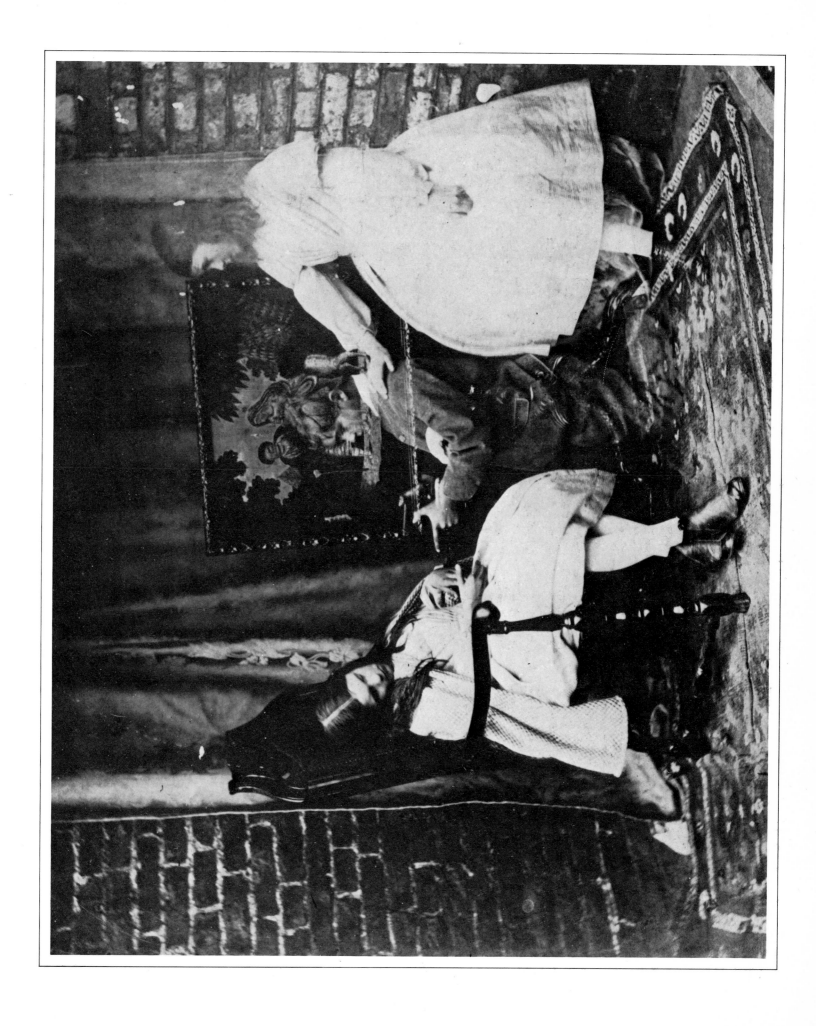

'The Ghost' (the Barry children), c.1857

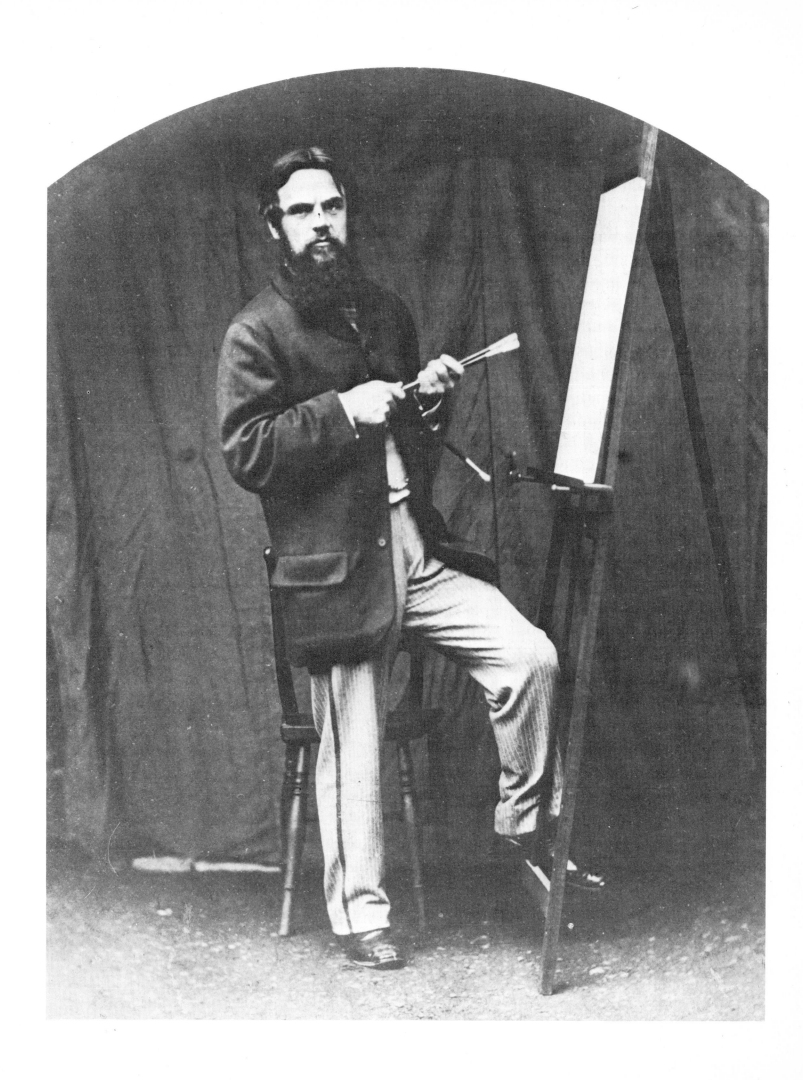

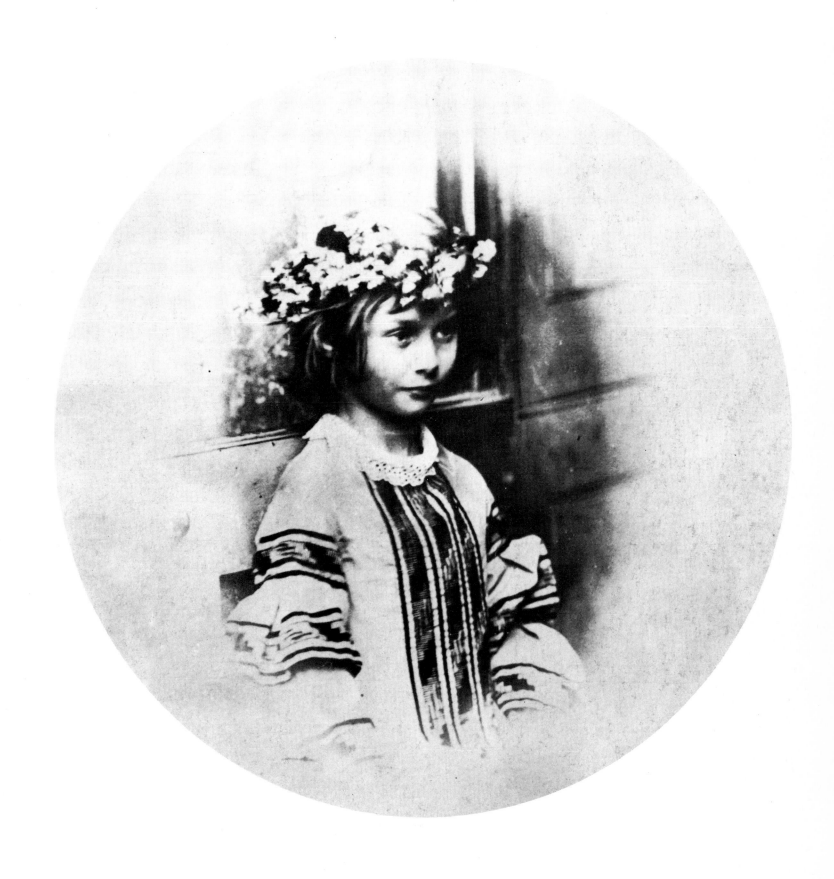

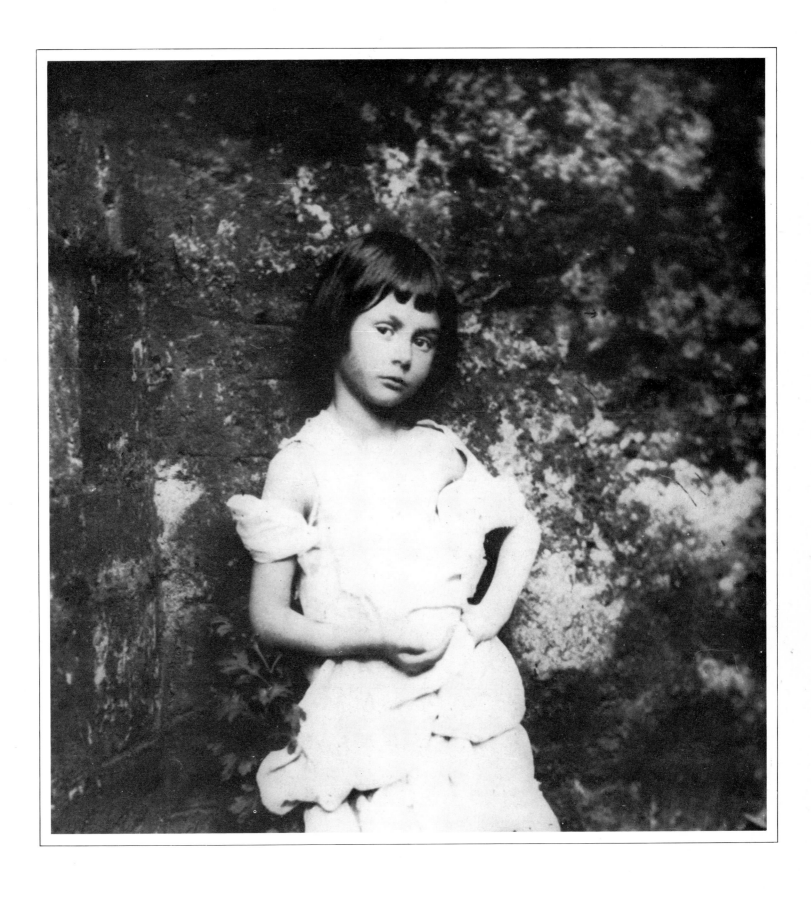

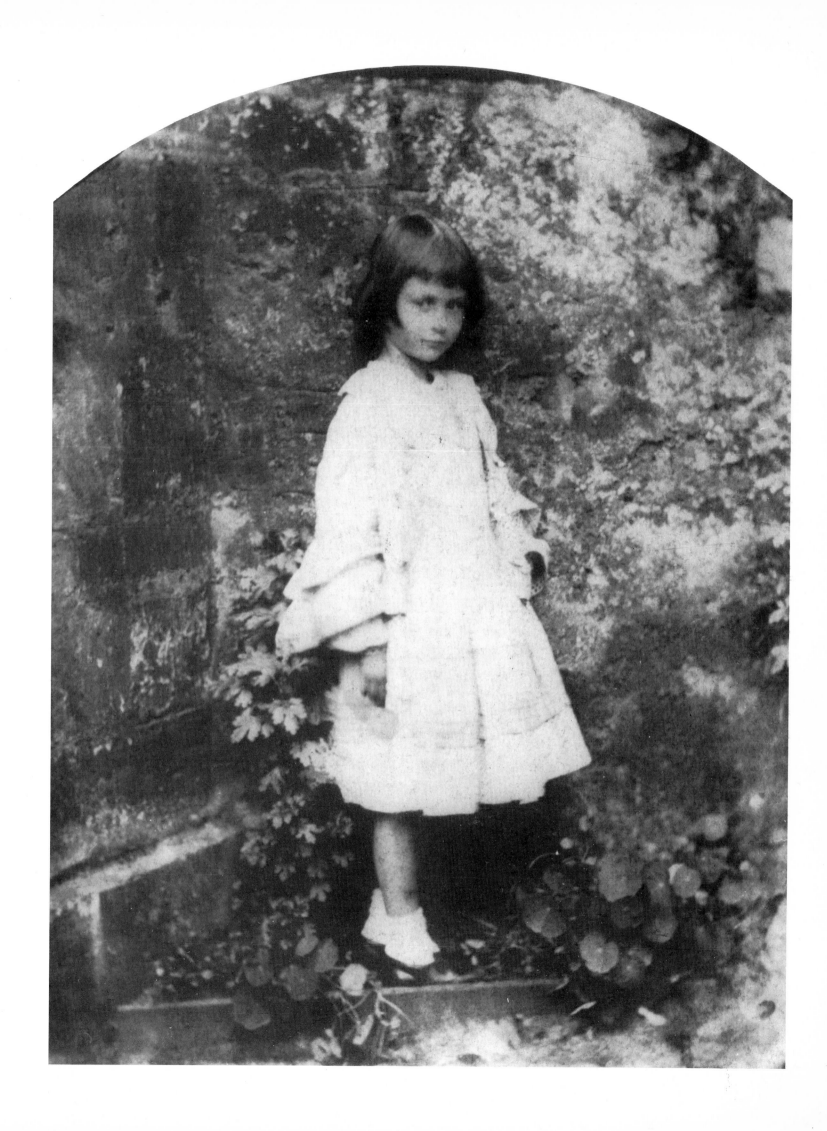

Alice Pleasance Liddell, 1859

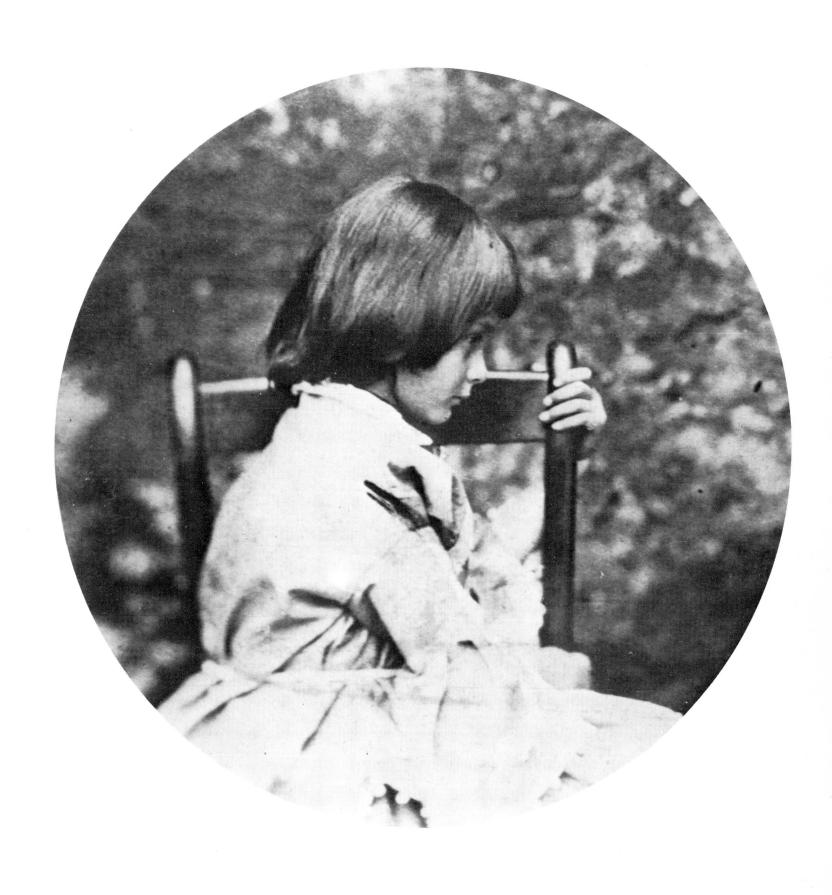

Alice Pleasance Liddell, 1859

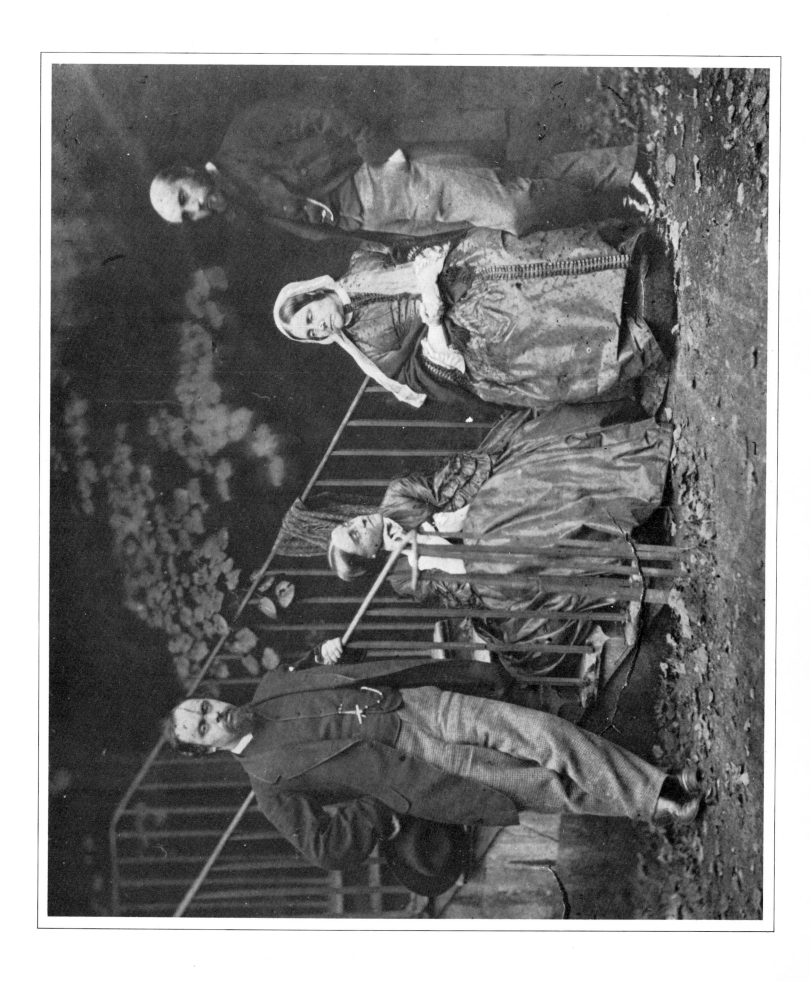

The Rossetti Family, 1863

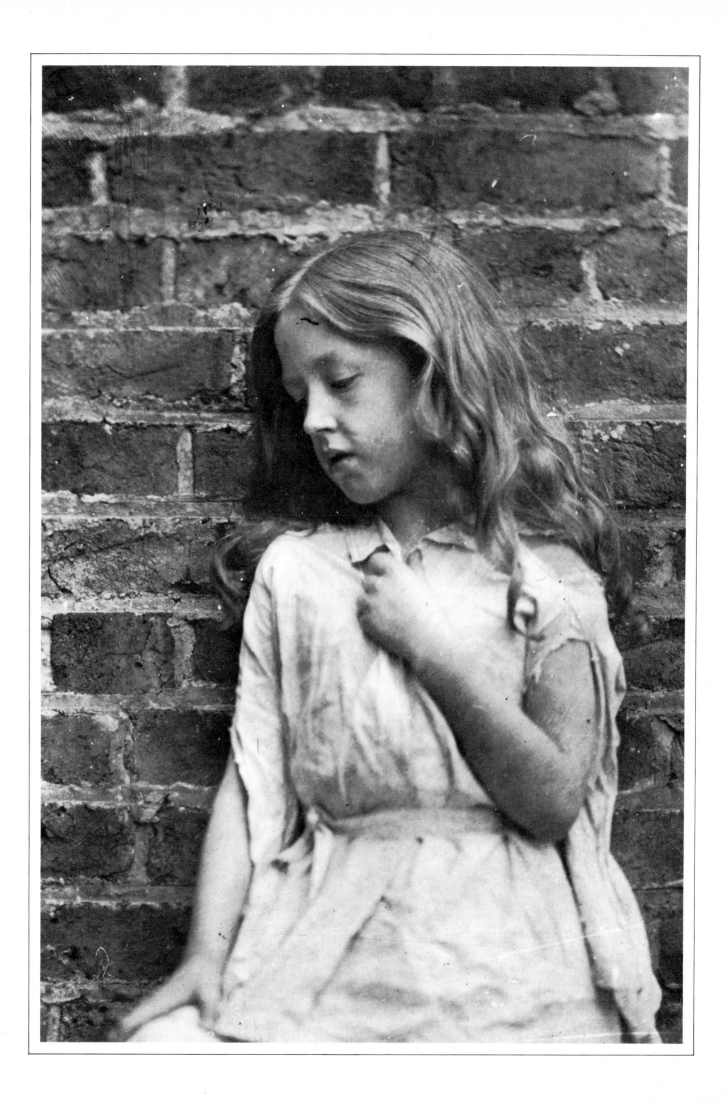

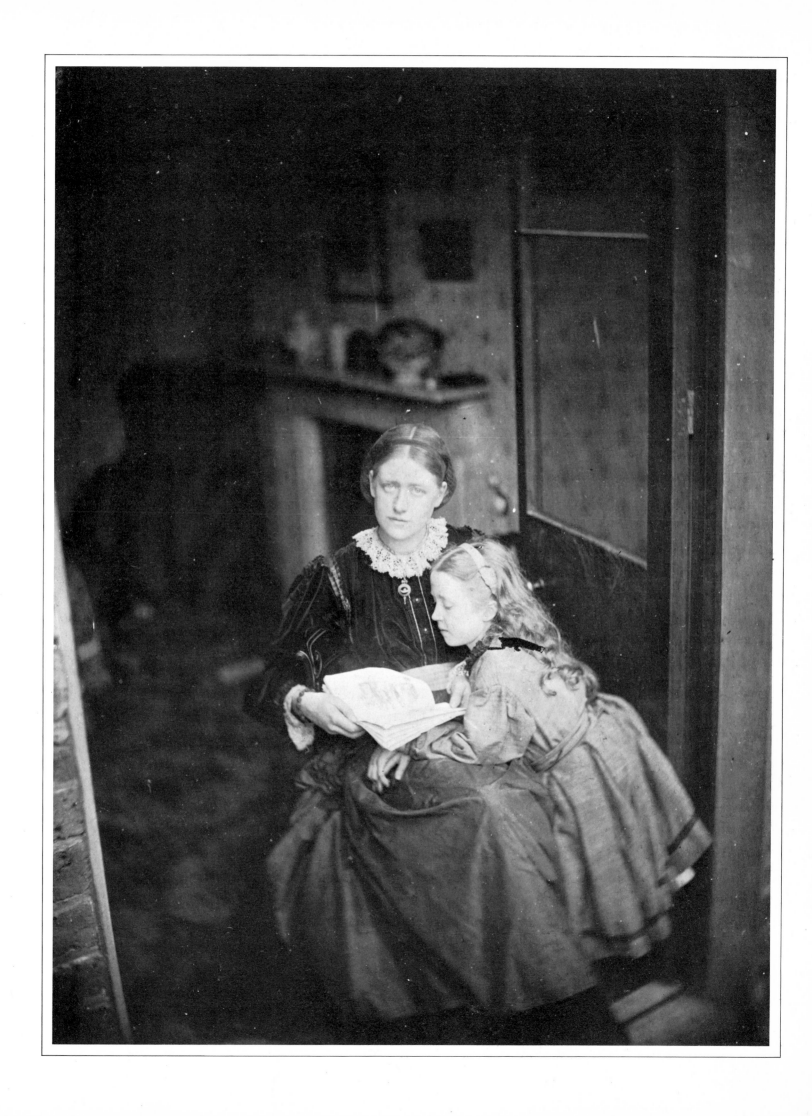

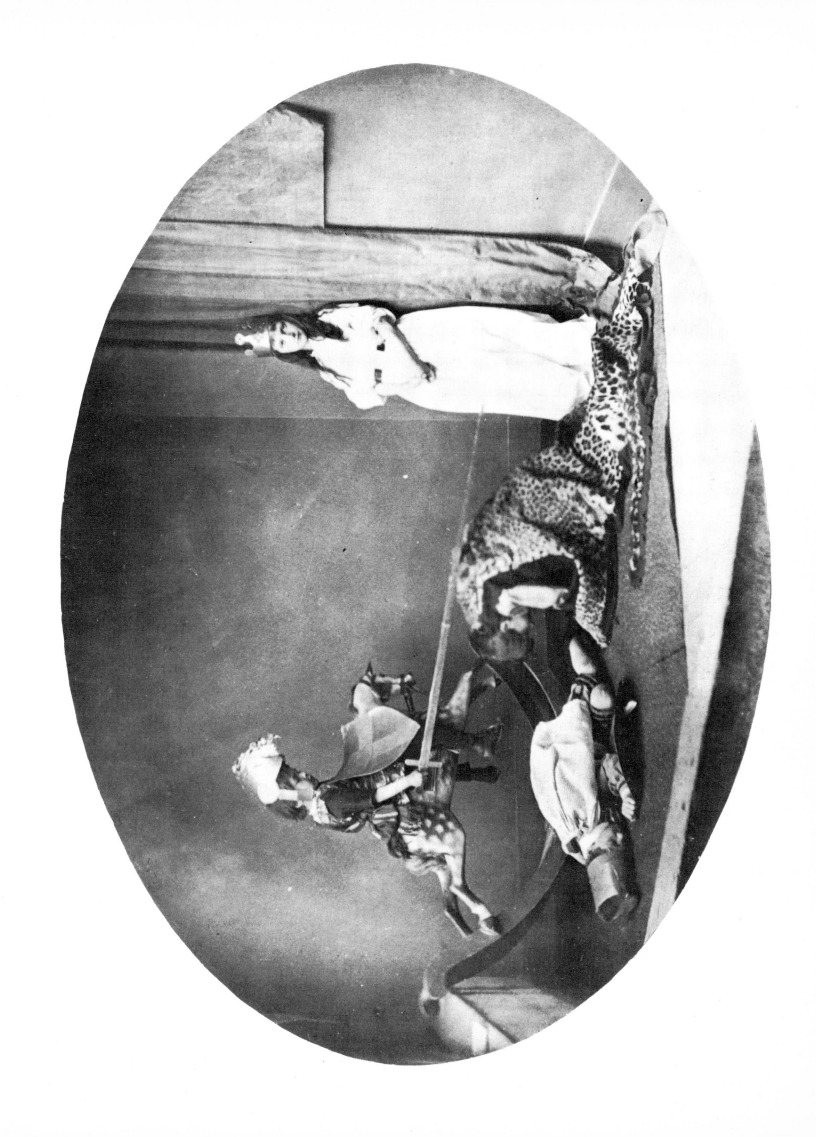

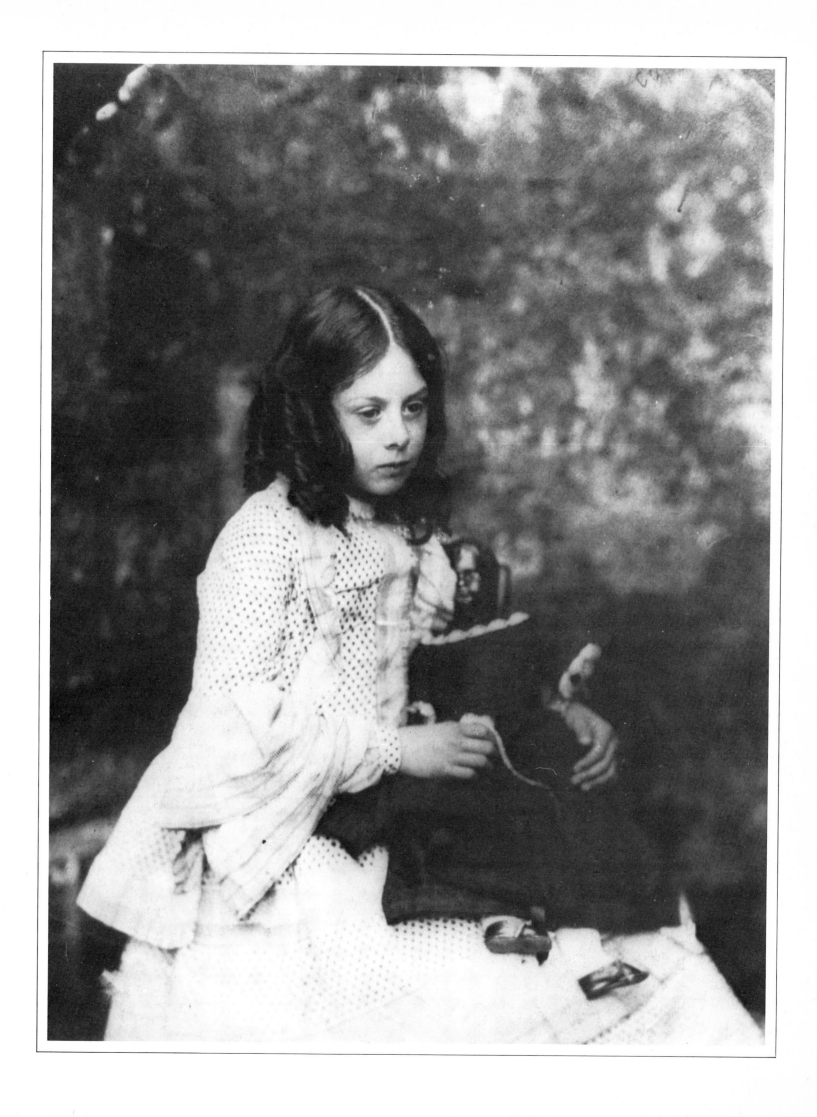

Lorina Liddell, c.1862

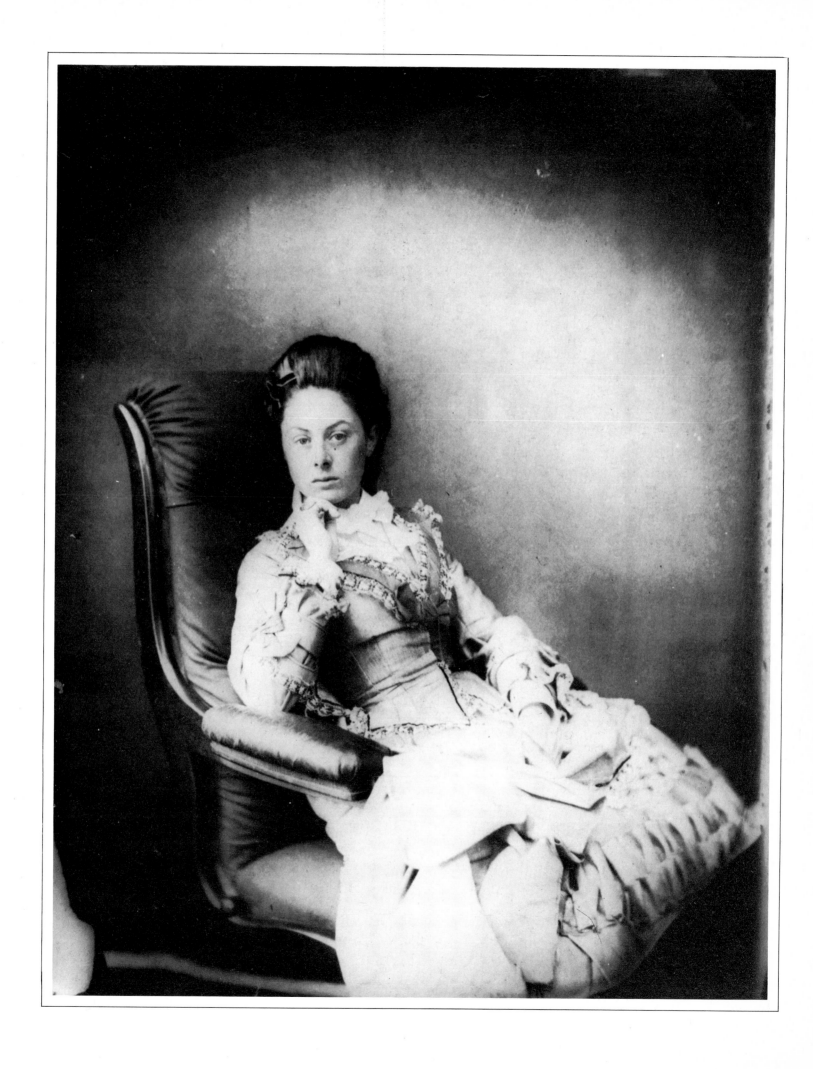

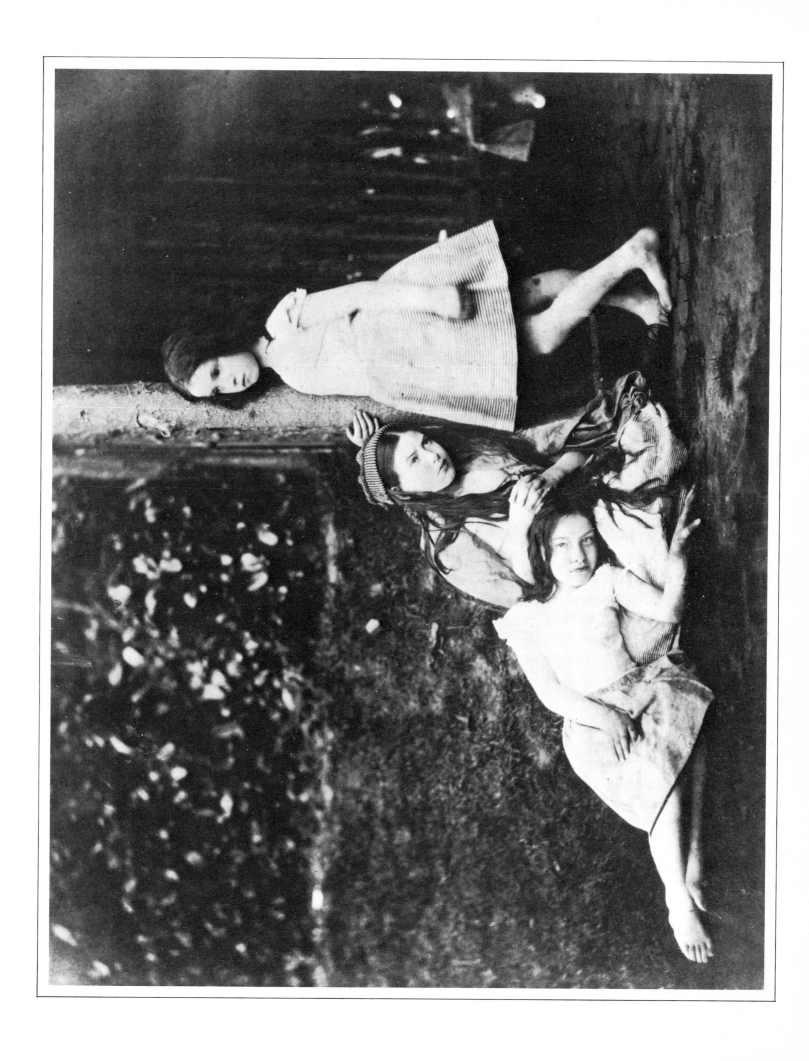

The Ellis Children

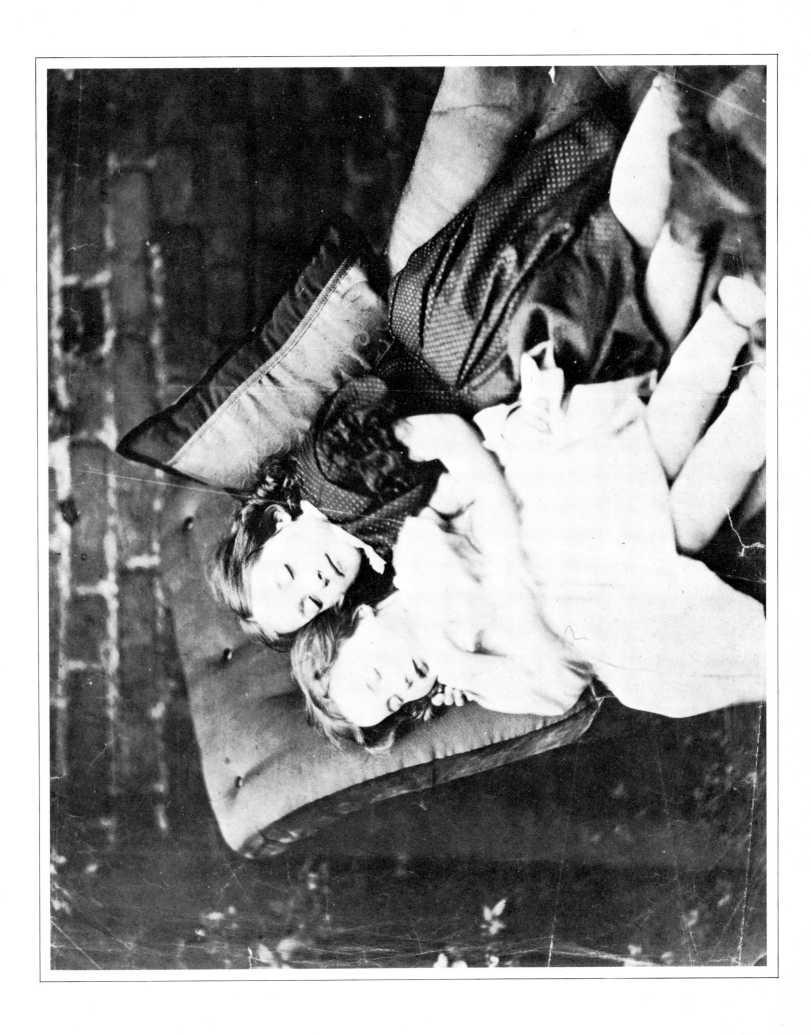

Agnes and Amy Hughes, 1863

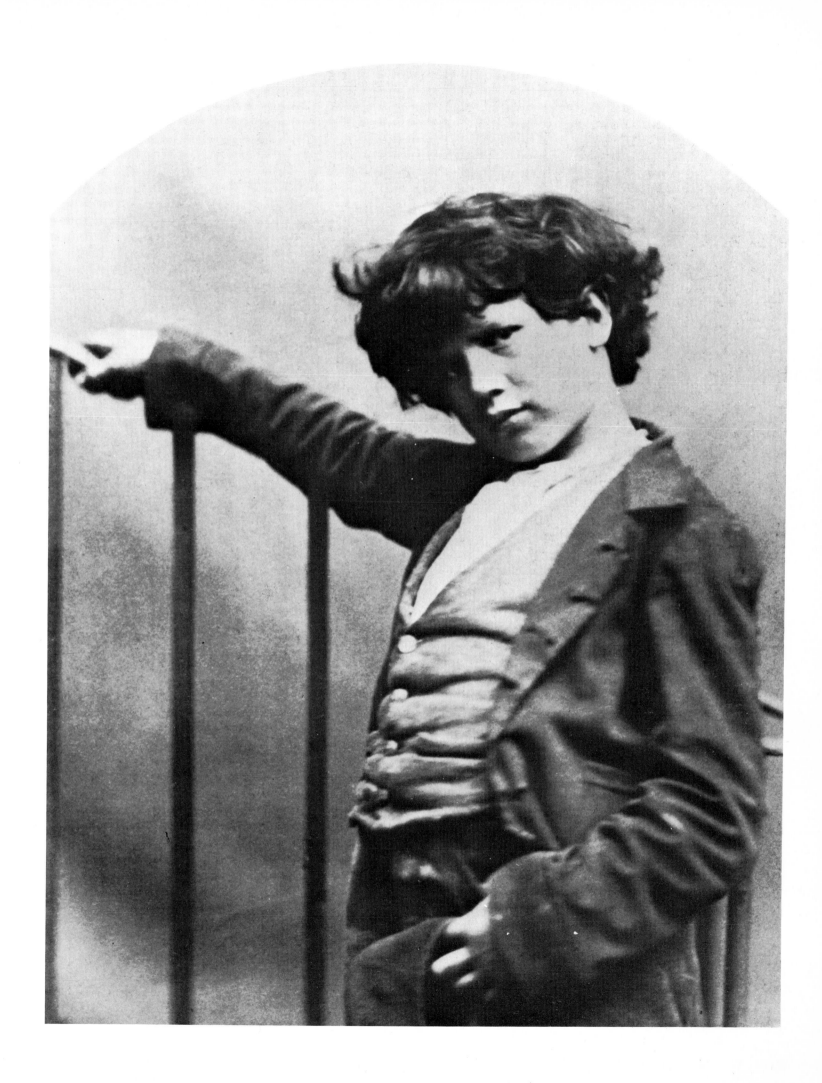

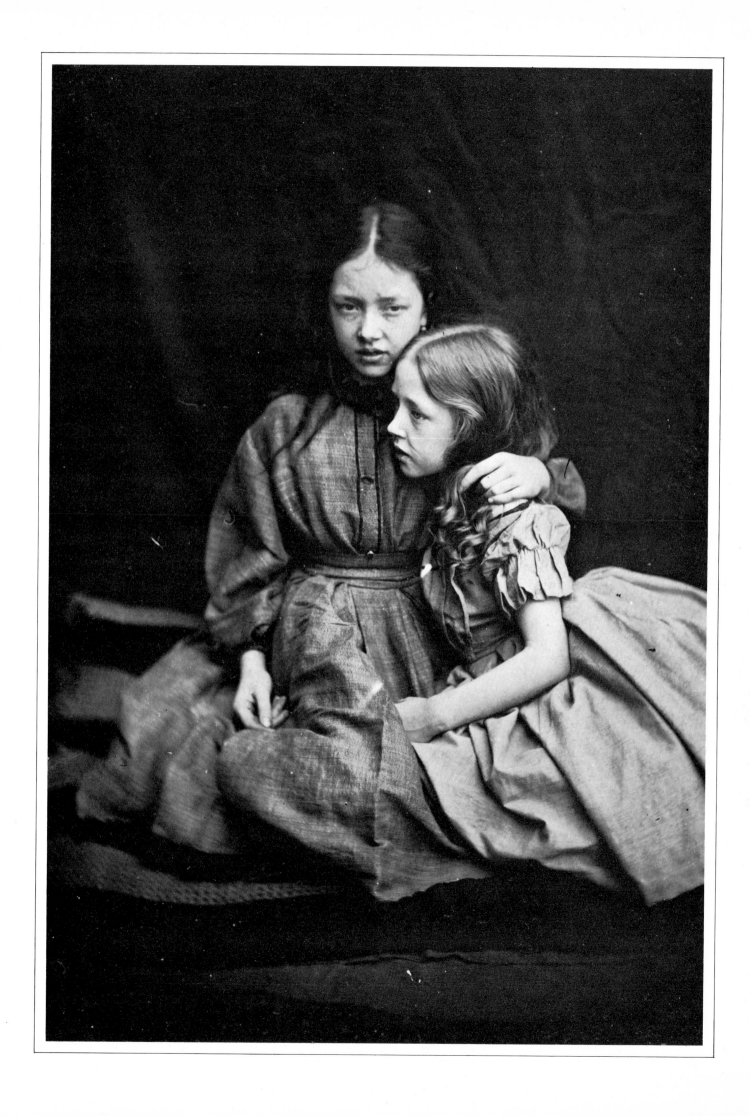

Marion and Florence, sisters of Ellen Terry, c. 1865

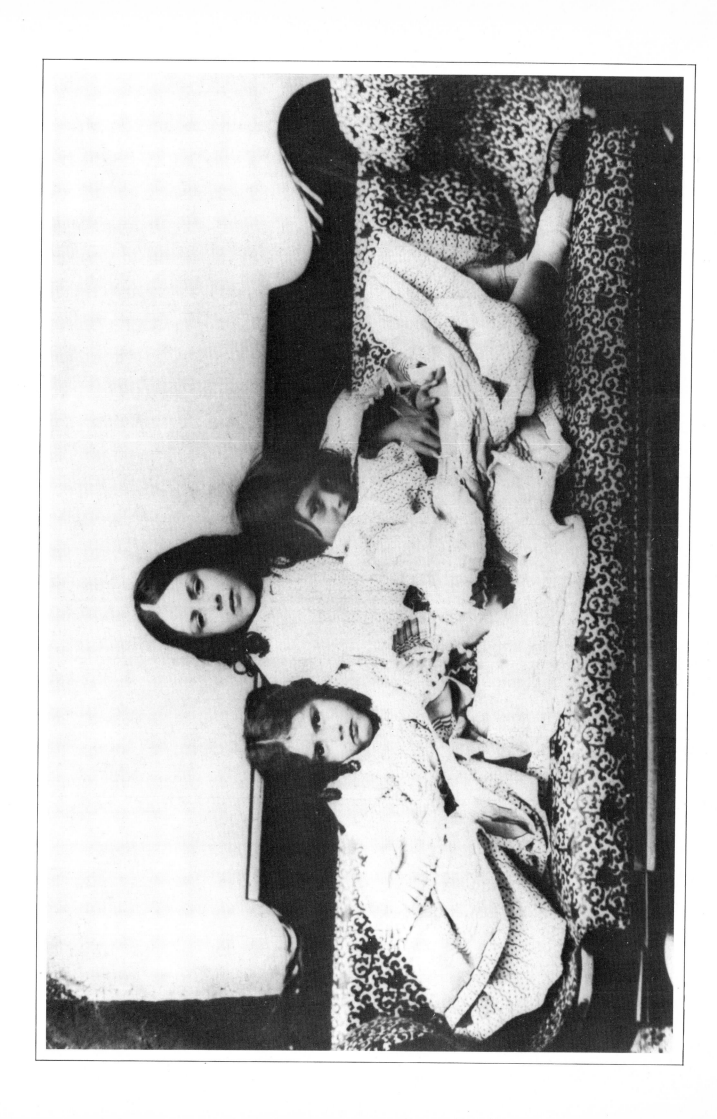

Edith, Lorina and Alice Liddell, 1859

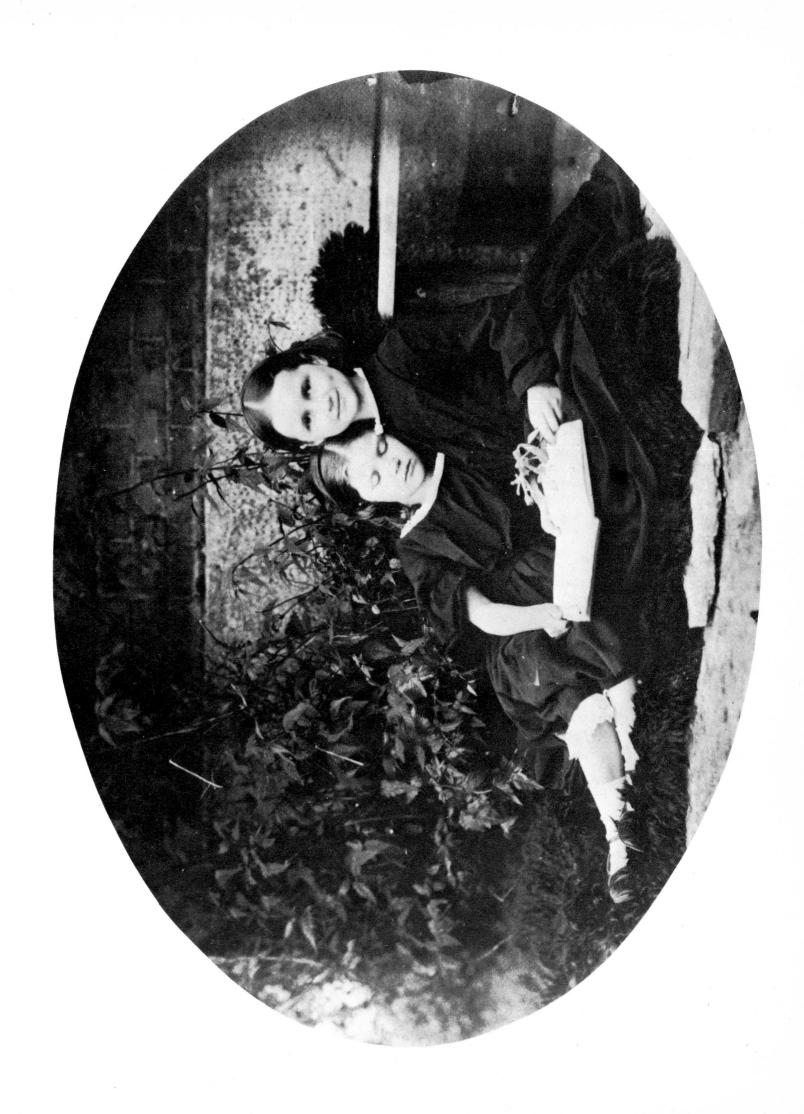

Ethel and Lillian Brody, 1862

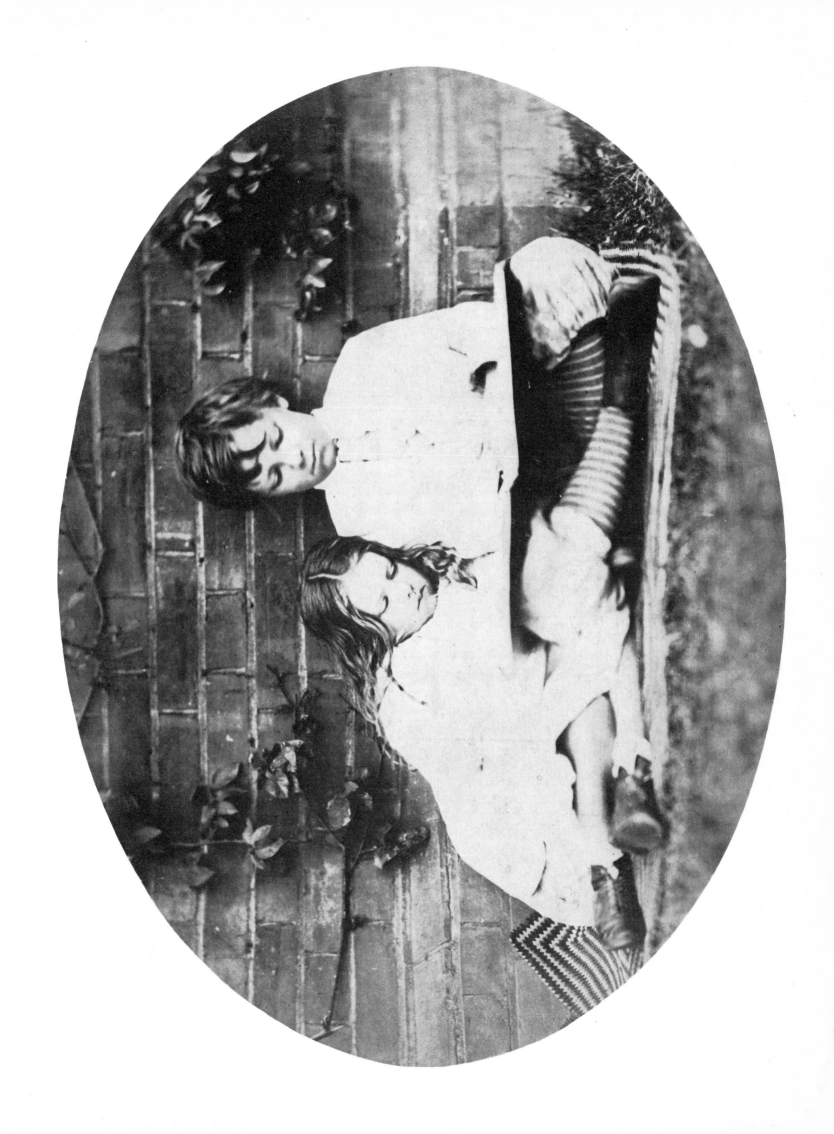